Ron Gorchov

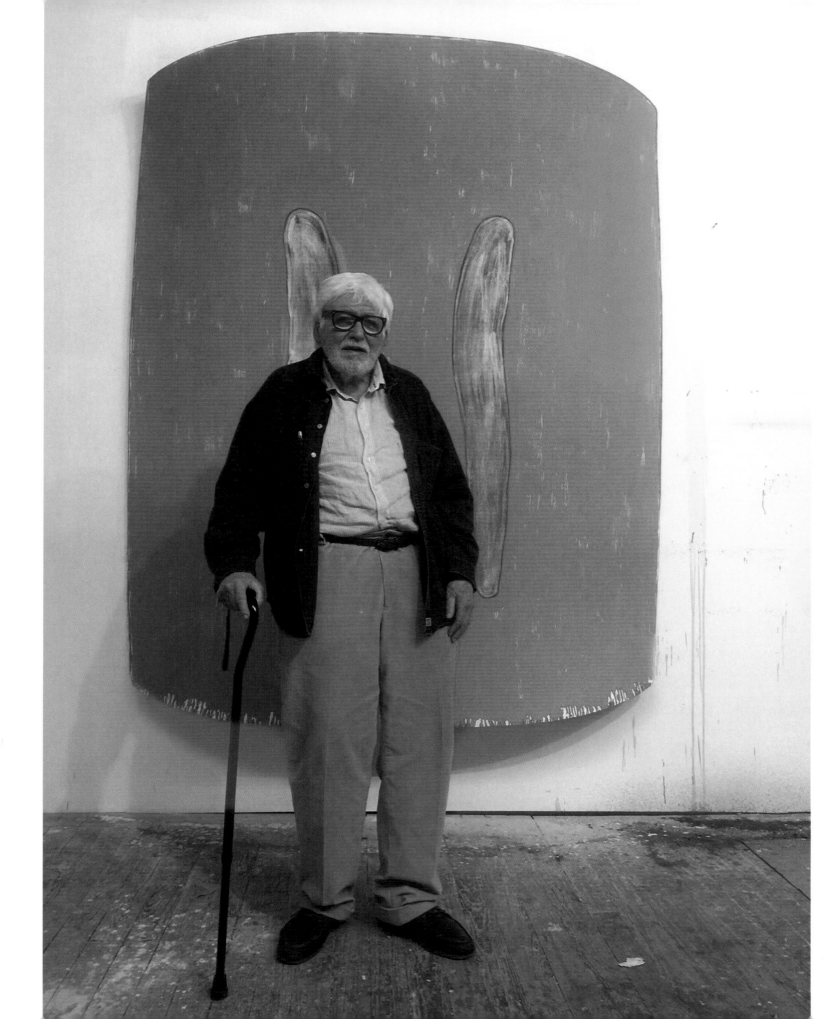

Ron Gorchov

THE LAST PAINTINGS

2017–2020

CHEIM & READ

Lucky Painter

BARRY SCHWABSKY

Of course the first thing anyone notices about Ron Gorchov's paintings is their shape, the fact that they are not planar. However, they are not "shaped canvases" like those of Ellsworth Kelly, Frank Stella, Joe Overstreet, or Elizabeth Murray (to cite just a few examples), and they are not sculptural in intent. They are formed as they are for reasons that are all about vision.

These paintings don't exactly come out to meet you halfway, but in their own subtle way they do approach you; they ever so slightly bend themselves to the form of your visual field. Yes, every painting is essentially a world that offers itself to be seen, but Gorchov's offer is, in its physical basis, more explicit than others'—and therefore, not necessarily *more* generous, but generous in a different way. Gorchov invented a new convention for painting, a convention that replaces the flat rectangle with a curved surface, at once concave and convex, and thus a new way for painting to accommodate its viewer into a spatial, visual world.

Gorchov himself remains something of a mystery. Despite the fact that the artist's first shows in 1960, 1963, and 1966 were with one of the most important New York galleries of the time, the Tibor de Nagy Gallery, whose archive is now housed at the Archives of American Art, images of the artist's work from before his discovery of the saddle-shaped painting in 1967 are difficult to find. The Museum of Modern Art holds *Comet*, 1974, and the Virginia Museum of Fine Arts holds *Wedding* from 1979, both oversized saddle paintings featuring Gorchov's two distinctive keyhole shapes, but works that predate this invention are difficult to find. Gorchov had an off-again, on-again relation with the gallery world, and he remained, as Robert Storr once put,

"a perennially 'emerging artist,'" more or less until he became an honored yet still underknown elder. [1]

An early mentor of Gorchov was an even more enigmatic character, the Russian émigré who renamed himself John Graham—a central figure in the American art of the interwar period along with Stuart Davis and Arshile Gorky whom Willem de Kooning sought out when he first arrived in New York in 1927. By the time Gorchov met Graham in the 1950s, he was an isolated figure out of tune with the times. Gorchov did not emulate his mentor's eccentric figuration. Graham's lesson, Gorchov told Nathlie Provosty in an interview, was "that painting is about space and proportions and where things go"; thus, more radically, "if it isn't the right color, it is not in the right place."[2] Never has the gospel of painting been proclaimed so concisely and so eloquently as that.

The rightness of color as the rightness of space is a matter of intuition. There's no rule that can tell you how to get that rightness right. Gorchov knew his art had no rules to follow. Art, as he understood it, "is when something's much better than it should be, when you just can't figure out why it's so good. In other words, you can't use craft." Such things are inexplicable. "Something can be really good," Gorchov said, "and nothing's right about it; it's irrationally good."[3] This is, I think, a more concrete way of expressing what Immanuel Kant wrote in his *Critique of Judgment* when he explained that fine art is a product of genius, which he defined as "a talent for producing that for which no definite rule can be given, and not an aptitude in the way of cleverness for what can be learned according to some rule." Kant went on to add: "Its products must at the same time be models, *i.e.*, be exemplary; and, consequently, though not themselves derived from imitation, they must serve that purpose for others." [4]

However, it should be pointed out that the unusual supports on which Gorchov painted were immaculately crafted. The shaped support was not yet an act of painting (which is required to be a work of genius); it is an underlying structure made

1 Storr, Robert. "Old Master Ron," in *Ron Gorchov: Donde Se Oculta el Alma/Where the Soul Hides.* Las Palmas: Centro Atlántico de Arte Moderno, 2011, p. 59.

2 Provosty, Nathlie. "Interview: Ron Gorchov with Nathlie Provosty." *The Brooklyn Rail.* April, 2014.

3 *Ibid*.

4 Kant, Immanuel. *Critique of Judgment* (1790). Trans: James Creed Meredith, SS46. Oxford at Clarendon Press, 1969. p. 307-8.

according to a set of rules designed by the artist, and necessarily made with craft. Thus, Gorchov's paintings are "shaped" only in the same way that any conventionally flat and rectangular canvas is shaped, namely as a given, a presupposition, *a priori*, and not as a declaration or a program. Or rather, I should say that his paintings are less shaped than a conventional rectangle, because the rectangle has something that no one's visual field has ever had: corners; the corners are where most paintings show their objecthood, their incommensurability with the visual field as an unbounded whole. Gorchov's self-invented saddle format convention eliminated such problems from the get-go.

The question then might be raised: Given the success of Gorchov's characteristic support in downplaying the painting's object-status in favor of its ability to function as the equivalent of a visual field, why haven't other painters taken up this convention? Why hasn't it, as Kant would have said, become a model for others? I would point out that the identification of the shape with its inventor in itself militates against this. Any other painter who attempted to systematically use this form would be pegged, to his or her detriment, as a mere imitator of Gorchov. Moreover, this would be an imitation not of his genius, that is, of what in his paintings is so good that you can't figure out why it's good, but only of the underlying craft. And while Gorchov was not imitated in this sense, he was enormously influential. His enduring reputation as a painter's painter means that in his work there is something other painters have been moved to emulate precisely in its mysterious inexplicability.

Gorchov did not, by the way, use Kant's word "genius" to name this unaccountable "something." He had a much more beautiful name for it: luck. He defined it this way:

> "When you get an impulse, and you feel like you know what color or what form, or you see how a line should be different—when you can see that, it almost feels like luck. Whenever you can grasp something and really be sure about it, it feels to me like luck."[5]

If the idea of abstract painting has any substantive content, it is surely this willingness to count on luck—to work without any rule, any criterion that tells you this form should go here, this color belongs there, this line will work just so. Gorchov's influence lies in his having dared to do this, with results that dare others to take similar risks, exhibit as much vulnerability, and try their luck.

5 Provosty, Nathlie. "Interview: Ron Gorchov with Nathlie Provosty." *The Brooklyn Rail.* April, 2014.

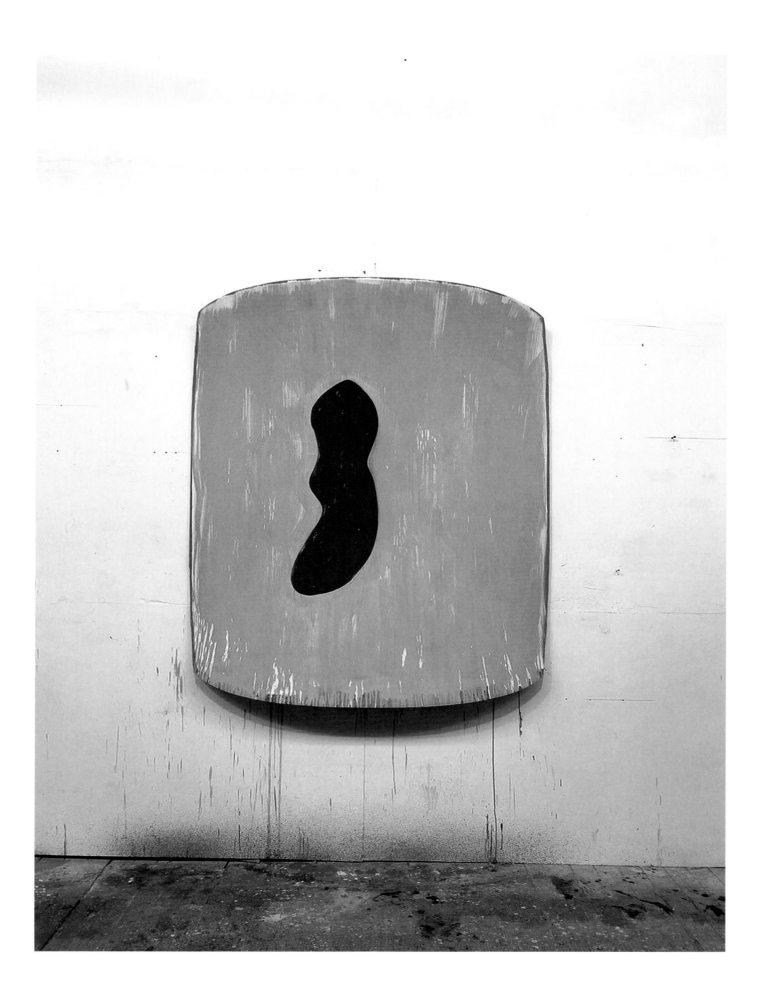

If he could not rely on rules, Gorchov did have habits and consistent ways of working. It's not only the shape of the support that immediately tells you whose work it is. It's also the character of the painted shapes he used—they really do have character!—and the way he used the paint itself. You might say Gorchov's painterliness was equally distant from Abstract Expressionist gesturalism and the uninflected, unitary color blocks of hard-edged painting. The color is thinned-out, soft, and often rather transparent, drippy rather than pasty: not something that wants to stay where it's been put. The paint's paths look to have spread a bit on their gravity-led journeys down the surface to form zones of striation at the bottom of Gorchov's surfaces, neither distinct nor entirely merged. These passages are highly variegated, and serve as a record of the paint's own adventures more than of the artist's will. It usually forms an encompassing field of a single complex color chord upon which float usually two, sometimes more forms of another color, or of other colors. Even in the rare cases when only one form is present in a Gorchov, the other, its partner, is still felt in its absence.

One is tempted to say that these are figures on a ground, though the fact that (as it usually appears to me) the "ground" has been painted around the figures, rather than the figures atop the ground, makes me want to resist the temptation: the surrounding space is not a background, a mere setting for the figures, but is actively forming them. Color—remember John Graham's lesson—is the place.

And we experience the two (in most cases) forms as being in dialogue. Their supple shapes suggest movement—both an internal movement like that of some blobby animate creature whose form can mutate as it takes the measure of its environment but also, therefore, movement of the two shapes in relation to each other. These fixed forms nonetheless evoke a sensation of non-fixity. More than that, they always give me the strange sensation that one form is addressed to each eye, that left and right are being addressed independently—and that in looking at the painting, my eyes are learning to work, like the hands of a pianist, with a kind of coordinated autonomy. It makes me feel a bit unfixed myself, in a pleasurably dizzying way.

A space where there's nothing to do but see, and an agreeable education for the eyes—a lesson in better and more independent seeing: What more could one want from painting than that? Gorchov had the luck to achieve such things. But how lucky we viewers are, to be able to join in his good fortune!

LEFT: *Partner*, 2017. Oil on linen. 65 x 55 x 10 in. / 165.1 x 139.7 x 25.4 cm.

1. *Hephaestus*, 2017. Oil on linen. 45 3/4 x 35 3/4 x 8 3/4 in. / 116.2 x 90.8 x 22.2 cm.

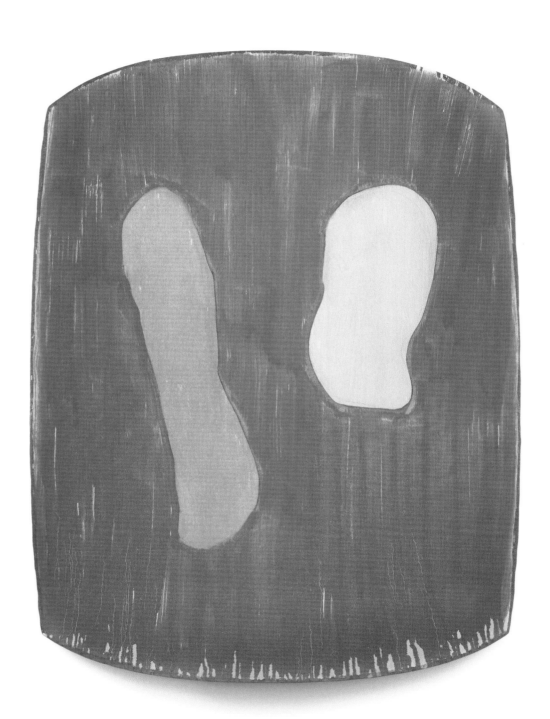

2. *Merope,* 2017. Oil on linen. 85 1/2 x 76 x 13 in. / 217.2 x 193 x 33 cm.

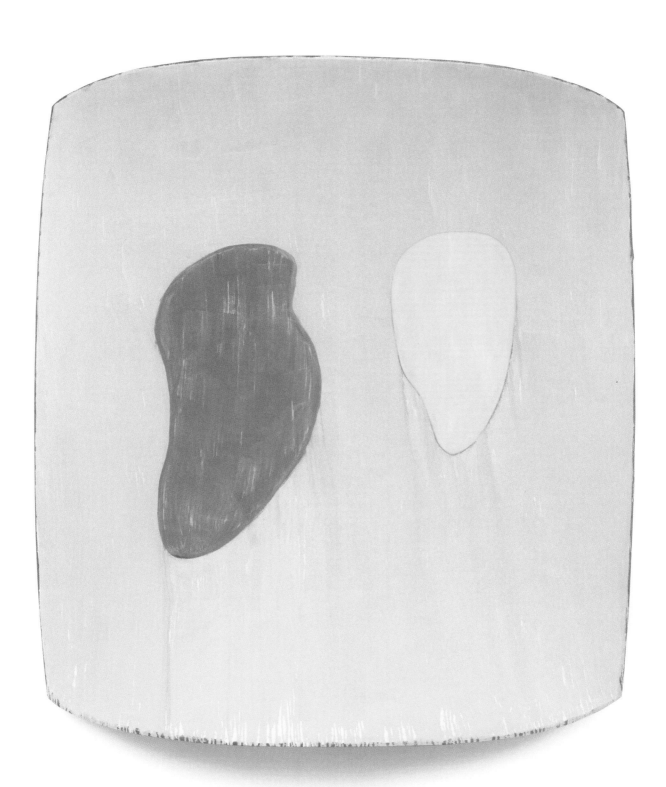

3. *Anna Perenna*, 2017. Oil on linen. 71 x 102 x 15 in. / 180.3 x 259.1 x 38.1 cm.

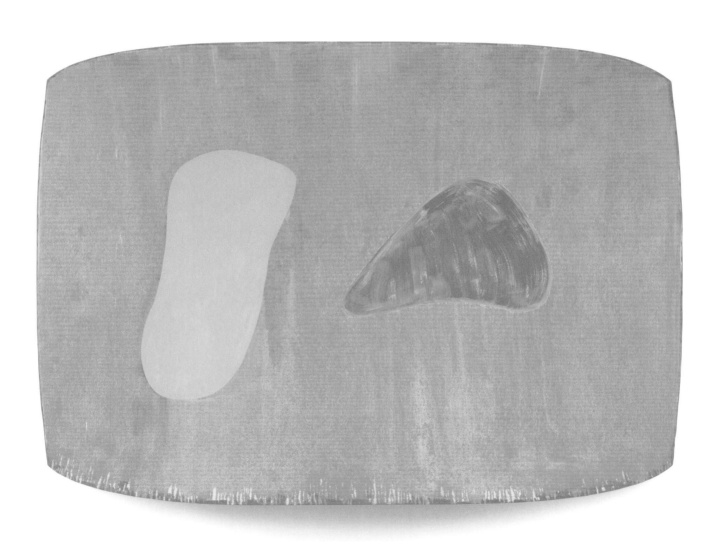

4. *Jocasta*, 2017. Oil on linen. 85 x 75 x 13 in. / 215.9 x 190.5 x 33 cm.

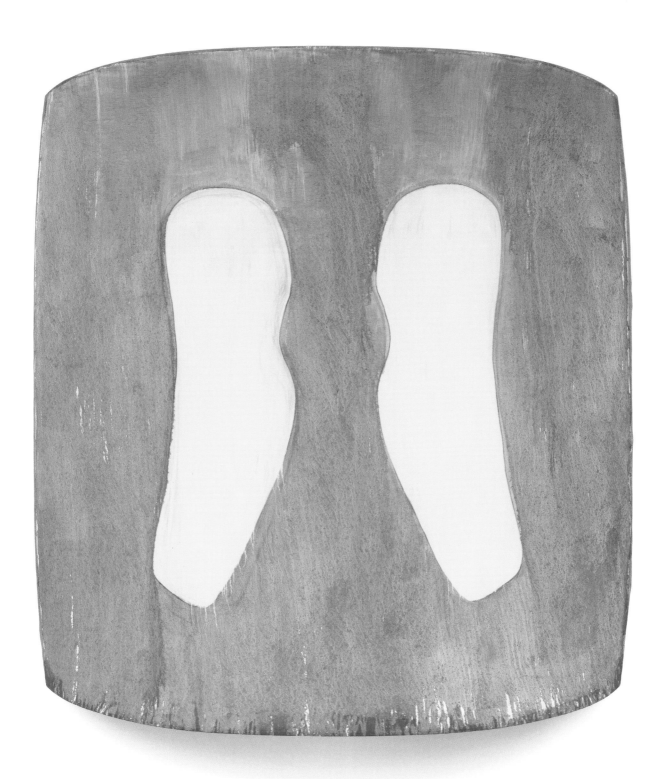

5. *Amythaon*, 2018. Oil on linen. 56 5/8 x 45 x 9 1/4 in. / 143.8 x 114.3 x 23.5 cm.

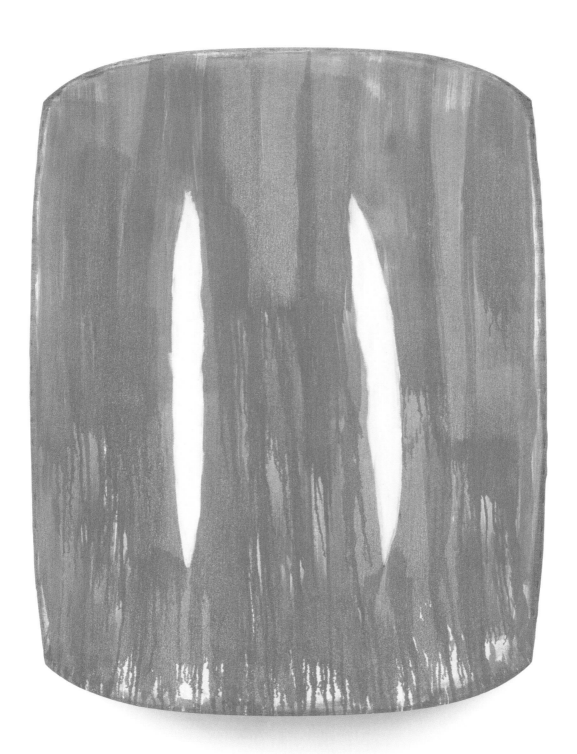

6. *Polynices*, 2018. Oil on linen. 64 1/2 x 55 1/2 x 10 1/2 in. / 163.8 x 141 x 26.7 cm.

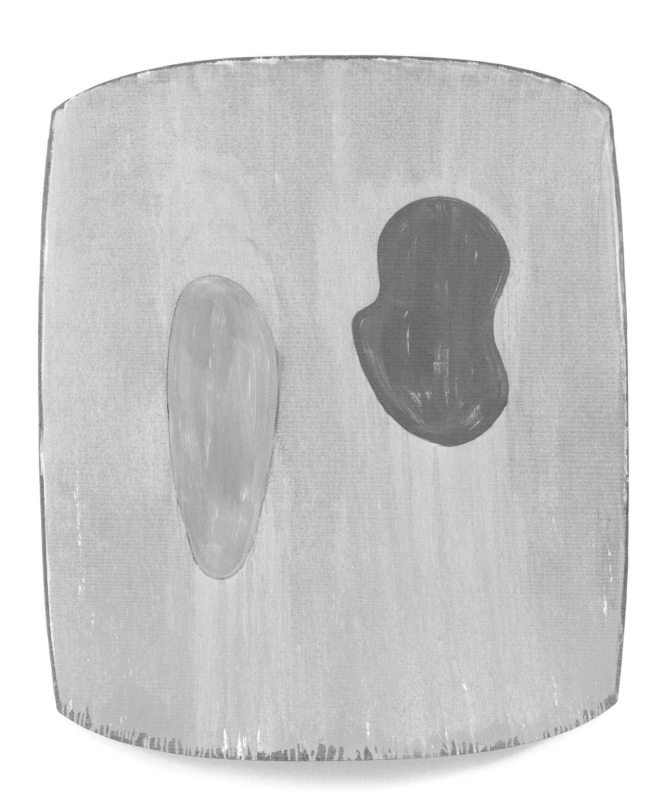

7. *Alkaios*, 2018. Oil on linen. 44 x 35 x 8 3/4 in. / 111.8 x 88.9 x 22.2 cm.

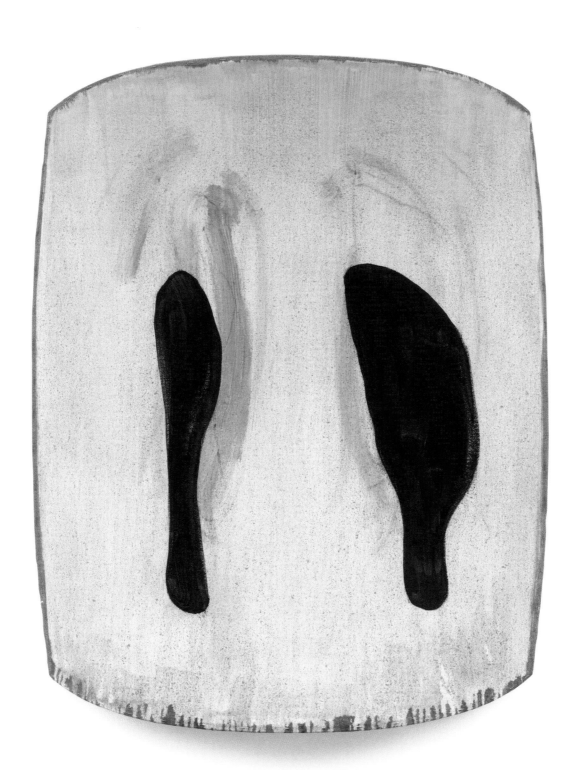

8. *Eteocles*, 2019. Oil on linen. 19 1/2 x 28 1/4 x 6 1/4 in. / 49.5 x 71.8 x 15.9 cm.

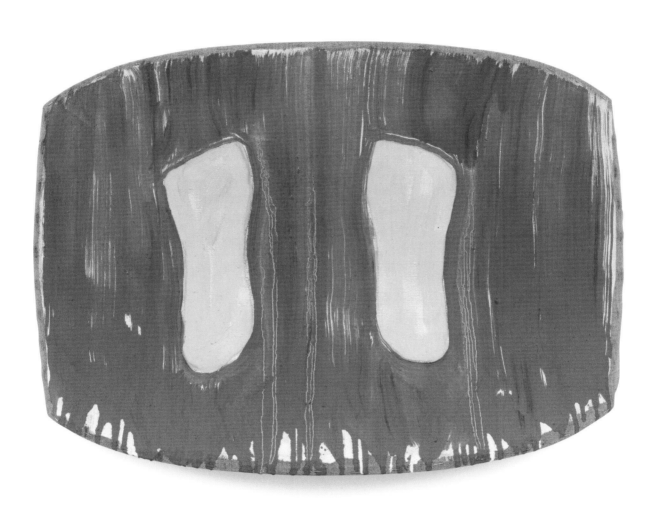

9. *Polyphemus*, 2019. Oil on linen. 44 x 35 x 8 1/2 in. 111.8 x 88.9 x 21.6 cm.

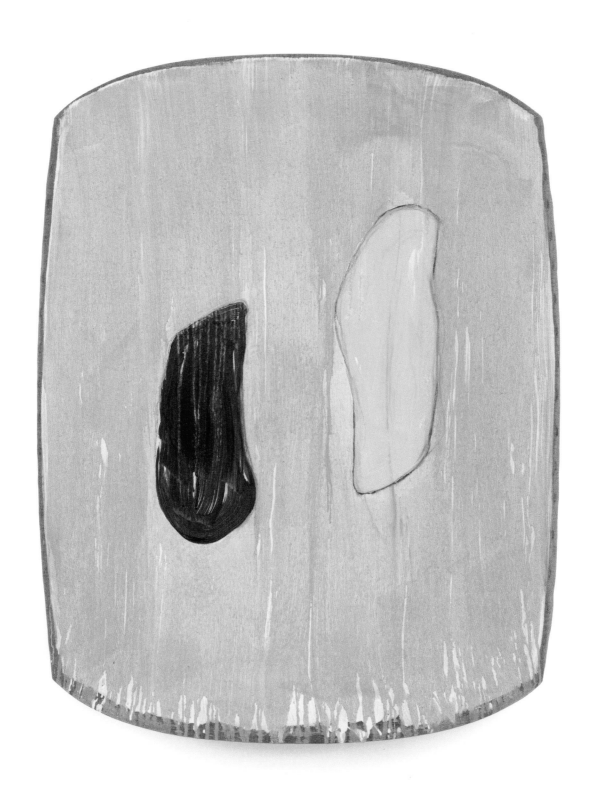

12. *Rhexenor*, 2019. Oil on linen. 35 1/4 x 44 1/2 x 9 in. / 89.5 x 113 x 22.9 cm.

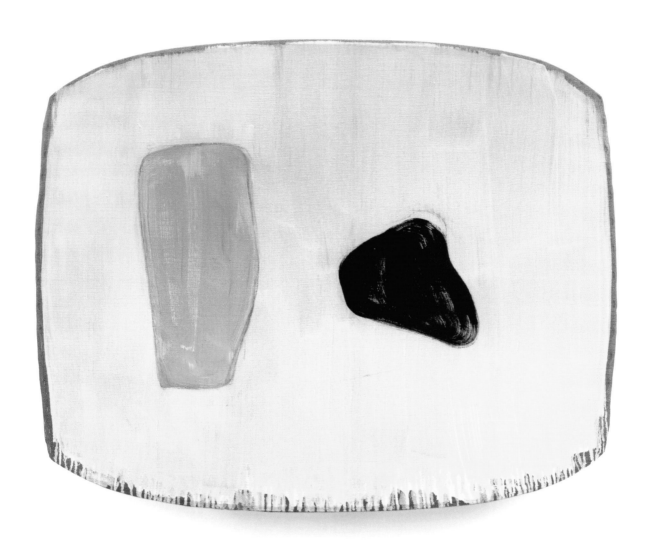

10. *Pontonoös*, 2019. Oil on linen. 46 1/2 x 66 x 13 in. / 118.1 x 167.6 x 33 cm.

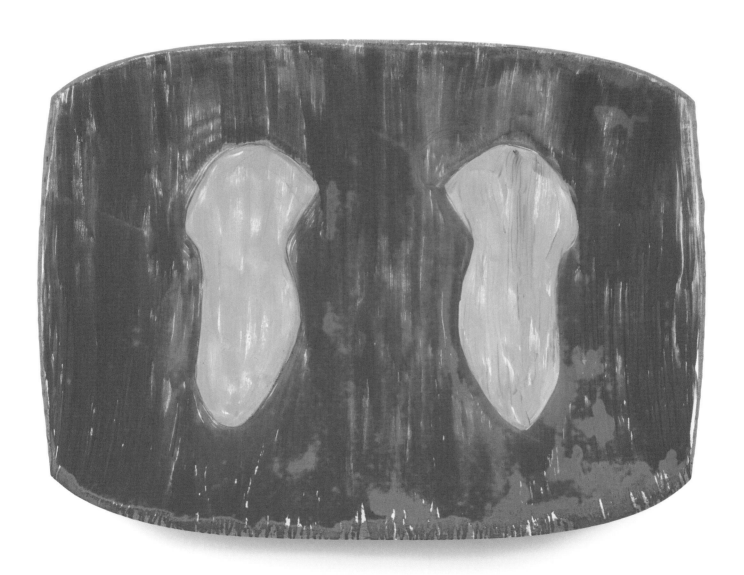

12. *Esperanza*, 2020. Oil on linen. 23 x 28 x 7 in. / 58.4 x 71.1 x 17.8 cm.

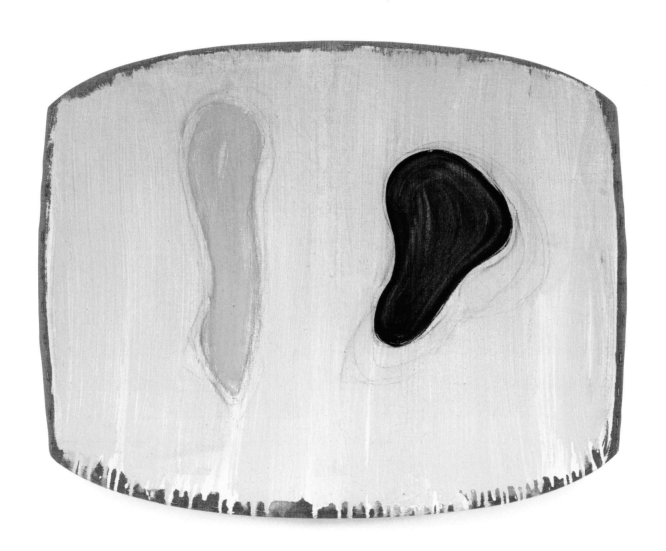

13. *July 4*, 2020. Oil on linen. 28 x 23 x 6 1/4 in. / 71.1 x 58.4 x 15.9 cm.

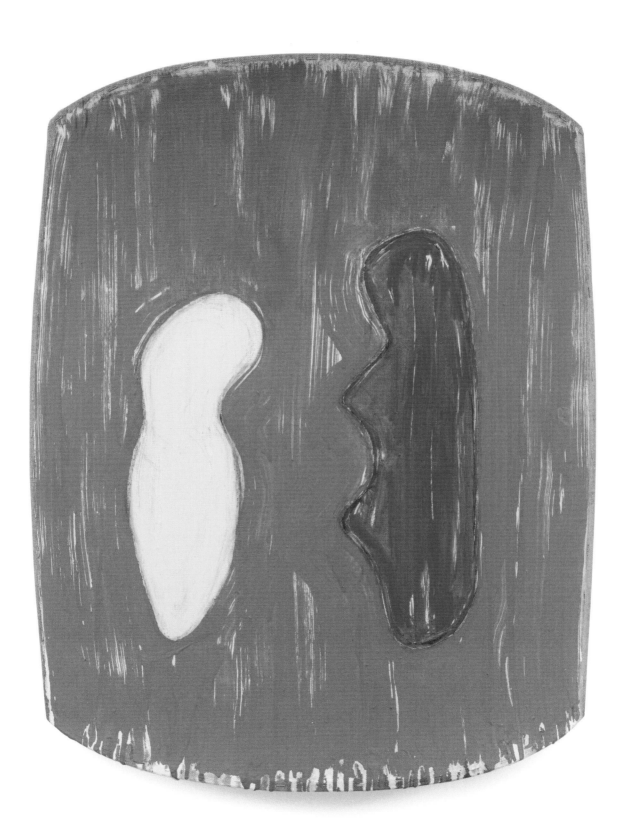

14. *Close Call*, 2020. Oil on linen. 29 x 23 1/2 x 7 in. / 73.66 x 59.7 x 17.8 cm.

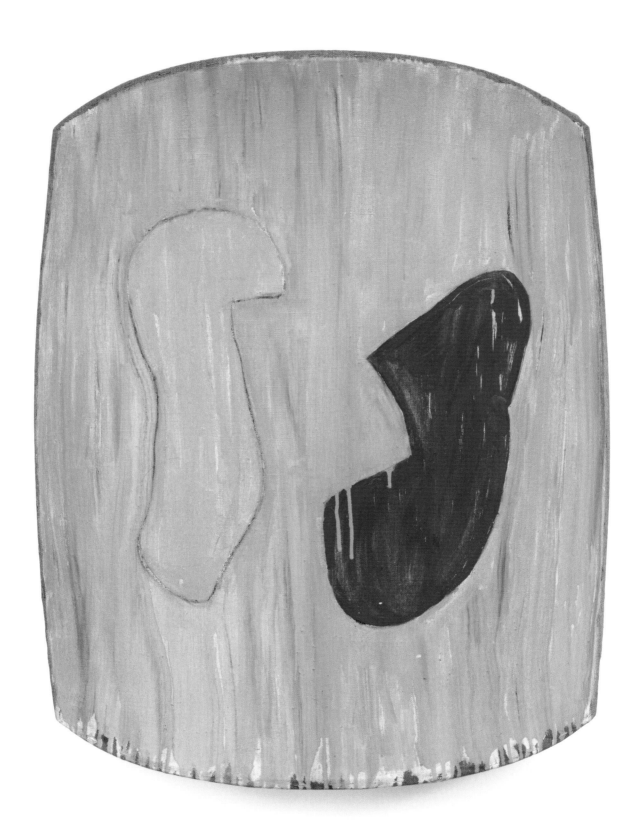

17. *H*, 2020. Oil on linen. 14 1/2 x 16 1/2 x 5 in. / 35.6 x 41.9 x 12.7 cm.

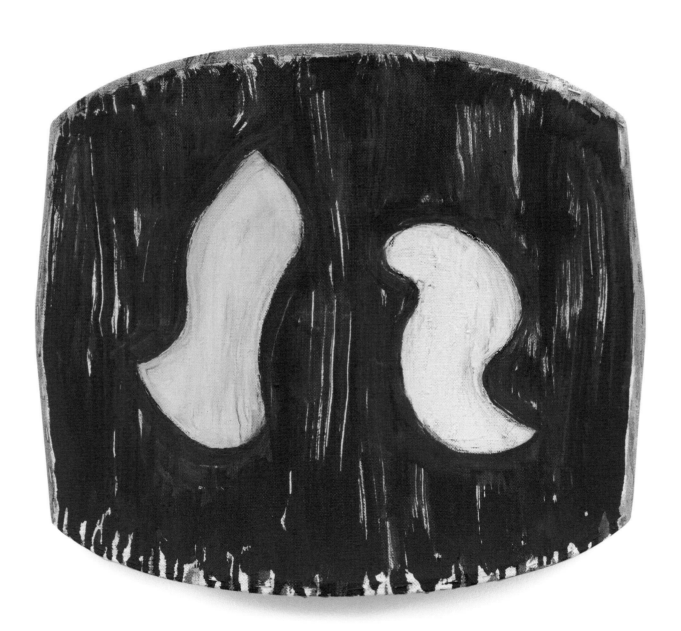

16. *Sir James Jeans*, 2020. Oil on linen. 35 x 45 x 9 3/4 in. / 88.9 x 114.3 x 24.8 cm.

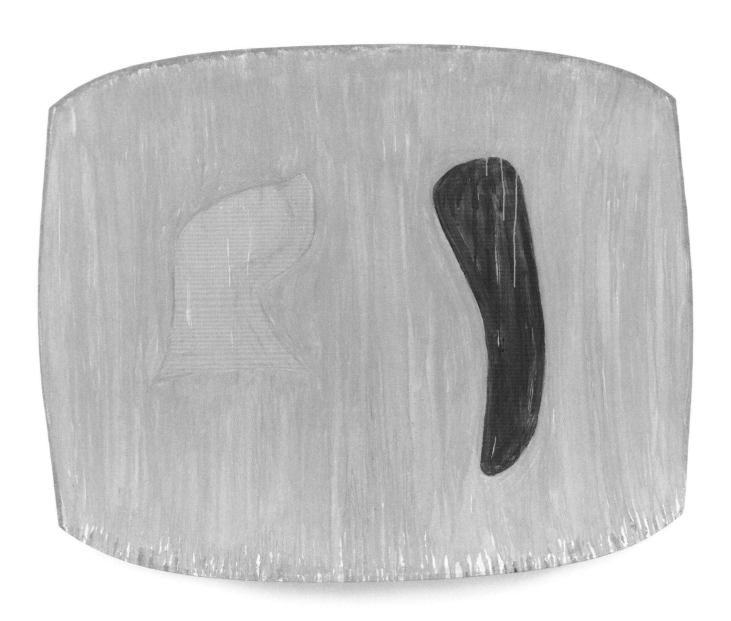

16. *Mauprat,* 2020. Oil on linen. 14 1/2 x 16 1/2 x 4 3/4 in. / 36.8 x 41.9 x 12.1 cm.

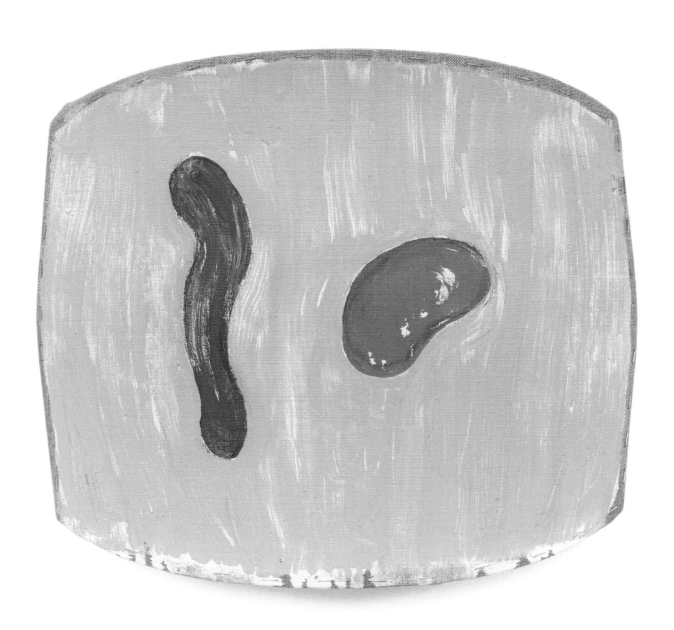

18. *Mocking Bird*, 2020. Oil on linen. 16 1/2 x 14 1/5 x 5 in. / 41.9 x 36.1 x 12.7 cm.

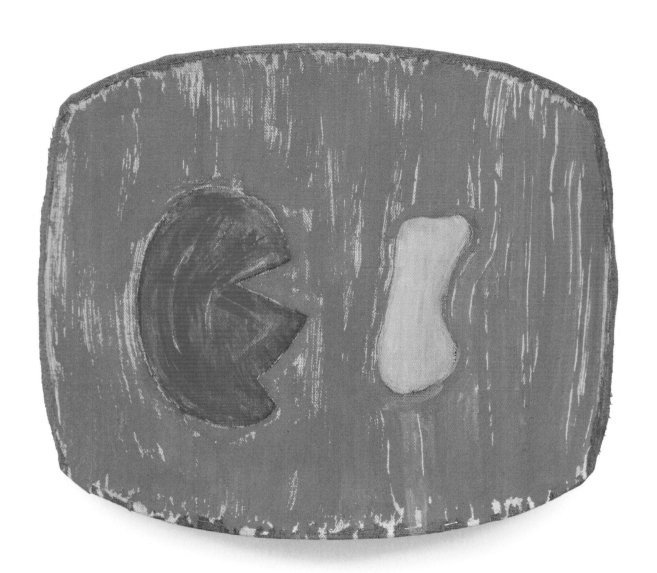

RON GORCHOV (born 1930, Chicago; died 2020, Brooklyn) studied painting at the Art Institute of Chicago before earning his B.F.A. at the University of Illinois, Urbana-Champaign in 1951. Tibor de Nagy Gallery gave the artist his first solo exhibition in 1960, and after a brief hiatus from the art world, Gorchov completed the first of his "saddle" paintings in 1967. Gorchov pursued this signature curved painting structure in countless variations for the next fifty years. His work was selected for the 1975 and 1977 Whitney Biennials, and he went on to be included in multiple exhibitions at the Museum of Modern Art, the Whitney Museum of American Art, and the New Museum.

Ron Gorchov's work has been the subject of solo exhibitions at Cheim & Read, New York (2019, 2017, and 2012); Modern Art, London (2019); Maruani Mercier, Brussels (2019); Galerie Max Hetzler, Berlin (2018); Vito Schnabel Gallery, St. Moritz (2016); Contemporary Art Museum, St. Louis (2014); Centro Atlántico de Arte Modern, Las Palmas de Gran Canaria (2011); and MoMA PS1, New York (2006). Gorchov's paintings are held by major museum collections including the Metropolitan Museum of Art, New York; the Museum of Modern Art, New York; the Art Institute of Chicago; the Everson Museum of Art, Syracuse; the Milwaukee Art Museum; the Nelson-Atkins Museum of Art, Kansas City; the Yale University Art Gallery, New Haven. This is Gorchov's fourth exhibition with Cheim & Read.

Published on the occasion of the Cheim & Read exhibition

Ron Gorchov: The Last Paintings 2017 – 2020

September 14 – December 18, 2021

We would like to thank Veronika Shear

DESIGN John Cheim ESSAY Barry Schwabsky

PRODUCTION Stephen Truax PHOTOGRAPHY Alex Yudzon

PRINTER Graphicom ISBN 978-1-944316-19-8